IMAGES
of America
CLEVELAND'S
SLAVIC VILLAGE

On the cover: **SOUTH HIGH SCHOOL, 1931.** South High School has been a neighborhood institution since 1894. The school has weathered three buildings—all on Broadway Avenue—and educated tens of thousands of Slavic Village sons and daughters. (Cleveland Press Collection/Cleveland State University.)

IMAGES
of America

CLEVELAND'S SLAVIC VILLAGE

Sandy Mitchell in association with
the Slavic Village Historical Society

ARCADIA
PUBLISHING

Copyright © 2009 by Sandy Mitchell in association with the Slavic Village Historical Society
ISBN 978-0-7385-6069-4

Published by Arcadia Publishing
Charleston, South Carolina

Printed in the United States of America

Library of Congress Control Number: 2008938679

For all general information contact Arcadia Publishing at:
Telephone 843-853-2070
Fax 843-853-0044
E-mail sales@arcadiapublishing.com
For customer service and orders:
Toll-Free 1-888-313-2665

Visit us on the Internet at www.arcadiapublishing.com

*To those, past and present, who strive to make
Slavic Village a better place to live..*

Contents

Acknowledgments 6

Introduction 7

1. Beginnings 9

2. Growth and Diversification 43

3. Churches, Clubs, and Schools 65

4. The People of Slavic Village 95

5. Rediscovering Cleveland's Slavic Heritage 103

6. Looking Forward 119

Acknowledgments

So many individuals helped to make this book a reality. I'd like to thank Glenn Sobola and the staff at the Slavic Village Historical Museum for cheerfully sharing their knowledge and materials. Also invaluable (as always) was Lynn Duchez-Bycko, the patient and extremely knowledgeable keeper of the more than 500,000 photographs that make up the Cleveland Press Collection at Cleveland State University Library. This project makes me realize what a treasure of original historical documents and images are readily accessible to the public right here in Northeast Ohio. I encourage readers to take advantage of these mostly free resources.

Thank you also to Melissa Basilone, my editor at Arcadia Publishing, for her patience, gentle guidance, and her confidence in me, the combination of which made this book so easy to produce.

I offer a special thanks to Terry Michelle Goodman of Platinum Photography in Cleveland for her excellent modern photographs of Slavic Village. And finally, thanks to my friend Daniel L. Smith. Without his support and encouragement, this book would never have been finished.

INTRODUCTION

The area of Cleveland we now call Slavic Village began as most of Northeast Ohio did, as part of the Connecticut Western Reserve, a parcel of land owned by the Connecticut Land Company and surveyed and populated with East Coast residents seeking adventure and fortune in the 19th century. Originally called Newburgh Township, the area began attracting settlers as early as the mid-1860s. The land was higher, cooler, and much less congested than the settlements on the swampy land near Lake Erie, now downtown Cleveland.

The end of the Civil War brought industry and growth to Cleveland. As factories and mills moved south along the Cuyahoga River, immigrant workers settled in the Slavic Village area to be near to their jobs in the plants. The neighborhood was home to rolling mills, chemical plants, and garment factories. The first residents were Irish, Scottish, and Welsh, but strikes at many of the plants brought an influx of Polish, Slovak, and Czech workers—those workers willing to work cheap and cross the picket lines. Tensions grew among the nationalities as the new immigrants replaced the original workers.

These new Slavic Village residents, mostly Poles, sought a place where they could worship in their native language and according to their old customs. St. Stanislaus Church, today a Polish shrine church, was completed in 1881 and became literally the center of the neighborhood. The area surrounding it, called Warszawa (little Warsaw), included bakeries, Polish groceries, sausage shops, and dry goods stores.

The new church served as a house of worship, but also a community center, helping new arrivals get acclimated and teaching English to both children and adults. As the population grew, St. Stanislaus would be joined by no fewer than six other neighborhood parishes, including the Czech St. John Nepomucene, Our Lady of Lourdes, and Immaculate Heart of Mary Church.

As with any neighborhood, it is the people who define Slavic Village. The area has produced a number of interesting personalities. Among these are Olympic sprinter Stella Walsh, former mayor and United States congressman Dennis Kucinich, and Fr. Anton Kolaszewski, pastor of St. Stanislaus Church and founder of Immaculate Heart of Mary Church.

Slavic Village gained its name about 30 years ago as the community strove to give the neighborhood a recognizable identity and to market the area throughout Cleveland as an ethnic destination, much like the city's Little Italy neighborhood. They dressed up Fleet Avenue in a "Hylander" style with Polish-themed murals and Old World building facades.

Today the neighborhood is a melting pot of descendents of the original Polish, Czech, and Slovak settlers as well as new African American, Puerto Rican, and Appalachian residents. Polish is still spoken in the neighborhood banks and stores and you will find Polish newspapers, records,

and DVDs behind the counter at many a Fleet Avenue merchant. The new construction and affordable housing prices have also brought a new type of resident—those from the Cleveland suburbs coming back to the city to be a part of its rebirth.

Slavic Village in the early 21st century sits on a pivot. Whether it will succumb to bad press, foreclosures, and crime or embrace its new residents and new construction projects and follow the lead of other historic Cleveland neighborhoods into a renaissance remains to be determined. The path it takes depends largely on its residents, but then the people of Slavic Village have always been tenacious.

One

Beginnings

The neighborhood that would eventually become Slavic Village was, in the early 19th century, a largely unpopulated forest. A part of the Connecticut Western Reserve, the neighborhood's tracts were surveyed by Moses Cleaveland, for whom the city of Cleveland was named, but few settlers had ventured away from Lake Erie to settle there. The first residents were Irish and Welsh immigrants as well as those of English descent that traveled west from Connecticut. Most found Newburgh Township, the precursor to Slavic Village, a more desirable place to live than the swampy, crowded, and disease-ridden neighborhoods at the lakefront in downtown Cleveland.

Industry came to the area in the mid-19th century, first in the shape of flour and other water-powered mills in the Mill Creek area and then to the Cuyahoga River valley, where iron ore and steel mills sprang up along the water's edge. Early workers at these plants were Irish and Welsh, but by the early 20th century, the majority of mill workers were of Polish and Czech descent.

These new arrivals created distinct enclaves within Newburgh Township. The Czechs settled around East Fifty-fifth Street and Broadway Avenue and the Poles created small communities at East Sixty-fifth Street and Forman Avenue and also around East Seventy-first Street and Ottawa Road. Soon Polish and Czech bakeries, banks, and, of course, churches were built.

NEWBURG

DIRECTORY OF NEWBURG

Ohio Chair Co Office 16 Hamilton Str
P S Ruggles Physician & Surgeon 10 Pittsburg St
C Caley Taylor 4 Pittsburg Str
M Nash Boot & Shoe Store 24 Hs 41 Walnut
G R Bowman Wagon Maker 25 Mechanics Str
Wm Varney Shingle Maker 51 Hs 10 Miles Str
Y Miles Dry Goods & Grocery Store 83 Pittsburg St
J G Moses Flouring Mill Bramord St Hs 6 Pittsburg St
Wm Bergin Cataract House 12
Jacob Drum Merchants Hotel 26
Chisholm Jones & Co Rolling Mill North of the Village
G R Bowman

NEWBURGH TOWNSHIP MAP. Long before it was Slavic Village, the area between Broadway and Harvard Avenues was part of Newburgh Township, a portion of the original Connecticut Western Reserve Territory, surveyed by Moses Cleaveland (left) in 1796. Early residents were Irish and Welsh settlers who came to Ohio to work in the steel mills and factories that had grown up along the Cuyahoga River. In the mid-19th century, Newburgh Township, located about three miles south of Cleveland, rivaled that city in size, and was more desirable to many because it was located on higher ground than the swampy land surrounding downtown Cleveland. Most of Newburgh was annexed to Cleveland in 1837 and 1905. Note that the *h* in Newburgh is optional; the name is seen spelled both ways on buildings and monuments. (Above, Slavic Village Historical Society; below, Cleveland Press Collection/Cleveland State University.)

WELSH ARCHITECTURE IN SLAVIC VILLAGE. The neighborhood's early Welsh roots can still be witnessed in a few of the buildings along East Sixty-fifth Street in the Warszawa District, such as this stone house on the corner of Sebert Street. Most of Newburgh Township's Welsh and Irish immigrants, however, settled a little further east, near Jones Road and Broadway Avenue. (Author's collection.)

FIRST WELSH CONGREGATIONAL CHURCH. The First Welsh Congregational Church (later known as the Jones Road Congregational Church), founded in 1860 at Broadway Avenue and Harvard Avenue, was the place of worship for the more than 2,000 Welsh living in Newburgh Township by 1870. Most of the Welsh immigrants worked in the iron mills along the Cuyahoga River. (Cleveland Press Collection/Cleveland State University.)

OLD NEWBURGH TOWN HALL. The Old Newburgh Town Hall, constructed in 1838, was located in the Miles Park district, which was once the social and commercial center of Newburgh Township. It was on the hall's front lawn that Newburgh boys drilled in the 1860s before going off to fight for the Union in the Civil War. (Cleveland Press Collection/Cleveland State University.)

NEWBURGH FIRE DEPARTMENT, 1880S. Newburgh Fire Station No. 11, opened in 1875, still stands at East Ninety-first Street and Walker Street. Water was pumped from three underground reservoirs, fed by Mill Creek, to fight neighborhood fires. (Slavic Village Historical Society.)

CREW OF NEWBURGH FIRE STATION NO. 11, 1933. Today the fire station is used as a storage facility. Look closely and one can see the hay hook used to lift bales of hay up to the loft on the Walker Street side of the building. (Cleveland Press Collection/Cleveland State University.)

EAST FIFTY-FIFTH STREET AND BROADWAY AVENUE. Newburgh Township had several distinct areas, divided largely on ethnic lines. Czechs were the first eastern Europeans to settle in the area and developed the neighborhoods around East Fifty-fifth Street and Broadway Avenue and along Tod Street (now East Sixty-fifth Street) and Fleet Avenue. (Slavic Village Historical Society.)

NEWBURGH BLACKSMITH SHOP, 1888. Polish immigrants arrived en masse in the 1870s and 1880s, settling in the East Sixty-fifth Street area, which they called Warszawa (Little Warsaw). Another settlement, near Harvard and Ottawa Roads, was dubbed Krakowa. This area was also nicknamed Goosetown, since most of the residents there were poultry farmers. (Cleveland Press Collection/Cleveland State University.)

MILL CREEK. Mill Creek, a tributary of the Cuyahoga River, formed the southern boundary of Newburgh Township. The three falls on the creek also provided the energy for several flour, carding, and sawmills in the area. The falls, which now sit across from the Slavic Village Historical Museum, were relocated in the early 1900s to make way for the Pennsylvania Railroad. (Cleveland Press Collection/Cleveland State University.)

MILL CREEK FALLS, 1933. Today the Mill Creek Falls are a pleasant stop to relax, an oasis in the midst of the big city. (Cleveland Press Collection/ Cleveland State University.)

HERRON'S MILL. Located near present-day Kinsman Avenue and East Ninety-third Street, Herron's Mill was one of several mills in Newburgh Township at the end of the 19th century. (Cleveland Press Collection/Cleveland State University.)

MILES PARK. Miles Park, on the eastern edge of the original Newburgh Township, was the village square in the late 19th century. The area was named for Charles Miles, who, with his six sons, was active in Newburgh politics in the early 19th century. This part of Newburgh was annexed to Cleveland in 1873. (Slavic Village Historical Society.)

16

HAULING POWDER KEGS, 1892. Polish workers were in demand for the mills along the Cuyahoga Valley because of their capacity and desire for hard work. In the 1880s, the average Polish factory worker labored 14 hours a day, six days a week, for a gross pay of $7.25 per week. Even still, many early Poles saved a portion of their factory wages and became small business owners. In addition, by the 1890s, a considerable number of Polish Americans had become doctors, lawyers, and notaries. (Cleveland Press Collection/Cleveland State University.)

EMMA BLAST FURNACE, 1880. The strike at the Cleveland Rolling Mill in 1882 created a lasting distrust between the Polish and Czech workers and the Irish and Welsh workers. When the Irish and Welsh refused to cross the picket lines, the mill brought 500 to 1,500 Poles from Europe to take their places. The strike of 1885 would play out somewhat differently. By this time, many of the eastern European workers had mortgages and families. When faced with a 50 percent reduction in wages that year, the Czech and Polish workers went on strike and were joined by many skilled (mostly English) workers. Violence erupted when the Cleveland Police met the strikers with clubs, and 35 strikers were injured. Instead of regaining some of their lost wages, the mills were closed until further notice. (Cleveland Press Collection/Cleveland State University.)

CATARACT HOUSE, NEWBURGH TOWNSHIP. Cataract House, at present-day Warner and Miles Roads, was one of two hotels in the Mill Creek area of Newburgh Township in the late 19th century. The wooden structure, built in 1840, burned to the ground in 1852, but was promptly replaced by a three-story brick building. Cataract House was a popular eatery and site for parties and grand affairs. The hotel closed in 1917 and the building was razed in 1931. Another of these grand meeting places was the Eagle Hotel. Both were known for their expansive ballrooms. (Cleveland Press Collection/Cleveland State University.)

BROADWAY AVENUE, 1885. By 1885, Broadway Avenue was a bustling commercial center. Stores there included V. Zoul's dry goods, E. L. Hechler drugstore, and McGreen's shoe store. (Western Reserve Historical Society.)

NEWBURGH OPERA HOUSE. Located on Broadway Avenue near Harvard Avenue, the three-story stone Newburgh Opera House hosted a variety of vaudeville and theatrical productions around the dawn of the 20th century. One of the most famous of these performers was Buffalo Bill Cody. (Slavic Village Historical Society.)

Grasselli Chemical Plant. Grasselli Chemical Plant, founded by Eugene Grasselli, provided employment for many early Polish and Czech immigrants. Opened in 1856 at the edge of the Cuyahoga Valley, the company included 14 plants when it was eventually sold to DuPont in 1928. (Cleveland Press Collection/Cleveland State University.)

EUGENE GRASSELLI. Members of the Eugene Grasselli (seen here) family were some of Cleveland's earliest philanthropists. Eugene's son Caesar was a founder of the Cleveland Museum of Art and the Cleveland Institute as well as an early trustee of Broadway Savings Bank. (Cleveland Press Collection/Cleveland State University.)

CLEVELAND WORSTED MILL. The Cleveland Worsted Mill, formed in 1893 from the failed Turner Worsted Mill, was one of the largest woolen mills in the United States in the 1920s. Located at East Sixty-first Street and Broadway Avenue, the mill was one of the neighborhood's—and Cleveland's—largest employers. In its heyday, the company controlled 11 plants in four states. Competition from synthetic fabrics and low-cost labor overseas and in the South caused the mill to close in 1956. The site, largely vacant for years, was destroyed by fire in 1993 (see pages 61 and 62). (Above, Robert Runyan/Bruce Young Collection; right, Cleveland Public Library.)

BROADWAY FLOUR MILLS. Not all of the industry in Newburgh Township was in iron ore and steel. The Broadway Flour Mills, located near Mill Creek, was one of several flour mills in operation in the late 19th century. (Cleveland Press Collection/Cleveland State University.)

NEWBURGH STATE HOSPITAL. The Newburgh State Hospital, originally the Northern Ohio Lunatic Asylum and later the Cleveland State Hospital, opened in 1855 on land donated by the family of later president James A. Garfield. The hospital, the second of its kind in Ohio, was designed to provide a rural, open setting conducive to good mental health. By 1900, the hospital had treated more than 10,000 patients. Like many facilities of its kind, the Newburgh State Hospital's methods came under scrutiny in the mid-20th century and the facility closed in 1972. Today the land is the site of the Mill Creek housing development. (Slavic Village Historical Society.)

AMERICAN STEEL AND WIRE, 1933. In the early to mid-20th century, Poles made up more than 50 percent of the workforce at the mills in the Cuyahoga Valley. Many women from the neighborhood took jobs also at the Cleveland Worsted Mills, Kaynee Blouse Company, and other area factories. This was especially true during the early 1930s, when all members of the family had to earn a few dollars to hold on to the family property. (Cleveland Press Collection/Cleveland State University.)

OVERVIEW OF SLAVIC VILLAGE AREA. Today Slavic Village is loosely defined as being bounded by East Forty-ninth Street to the west, Broadway Avenue to the north and east, and Harvard Avenue to the south. (Slavic Village Historical Society.)

HARVARD AVENUE IN NEWBURGH TOWNSHIP. Harvard Avenue was originally called Hamilton Avenue, named for Judge Hamilton. It became Harvard Avenue in 1905 when many neighborhood streets were renamed by the City of Cleveland. (Cleveland Press Collection/Cleveland State University.)

Streetcar. The Broadway and Newburgh Street Railway began electric streetcar service to Slavic Village in 1893. In addition to service down Broadway Avenue, the route included portions of East Forty-ninth Street, Fleet Avenue, Harvard Avenue, and Lansing Avenue. The company merged with the Brooklyn Street-South Side Street Railroad and the East Cleveland Railway to form the Cleveland Electric Railway Company in 1893 and eventually became part of the Greater Cleveland Regional Transit Authority (RTA). (Slavic Village Historical Society.)

BROADWAY AND HARVARD, 1903. Most Slavic Village streets changed names at least once. For instance, in 1874, Fifth Avenue became Fleet Avenue and First Avenue (now Lansing Avenue) was renamed Fremont Street. Hamilton Street became Harvard Avenue and Prospect Street changed to Jones Road. (Cleveland Press Collection/Cleveland State University.)

BROADWAY AND EAST FIFTY-FIFTH STREET, 1918. Broadway Avenue and East Fifty-fifth Street was a hub of commercial activity during the early 20th century and the center of the area's Czech community. Called Karlin, after an early Czech settler and saloon owner, the area developed during the 1890s. The two-block commercial district at Broadway and Fifty-fifth boasted more than half a dozen banks, including the Broadway Bank (below), and the streetcars provided an easy way for residents to get downtown. (Slavic Village Historical Museum.)

Police Station No. 4 on Wilson Street. In the 19th century, this police station sat on Wilson Avenue (East Fifty-fifth Street) just north of the Olympia Theater. Also near the station, traveling north on Wilson Street, were Janouseck Millinery, Eyerdam barbershop, Kumler carriage shop, a livery stable owned by Peter Yost, and Morgan's apple orchard. (Cleveland Police Museum.)

OLYMPIA THEATER, 1914. The Olympia Theater, which opened in 1912, was one of several vaudeville and grand motion picture houses in the Broadway Avenue area. Others included the Broadway Theater at 4628 Broadway Avenue, Broadway American Company at 4825 Broadway Avenue, the Columbia Theater at 6421 Broadway Avenue, and the Harvard Theater at 8414 Broadway Avenue. The Olympia Theater closed in 1980 and the auditorium was destroyed during a renovation project. The lobby, however, remains. The Olympia Theater (called the Luce Theater) was featured in the 2001 movie *Welcome to Collinwood*, with George Clooney, which was partially filmed in Slavic Village. (Western Reserve Historical Society.)

REID BLOCK DECORATED FOR MCKINLEY INAUGURATION. Isaac Reid was a successful property owner and farmer in Newburgh Township at the dawn of the 20th century. He owned the Reid Block at Broadway and Harvard Avenues as well as the land that would become Harvard Grove Cemetery. Above is the Reid Building adorned in bunting to celebrate the presidential inauguration of Canton native William McKinley in 1901. (Cleveland Press Collection/Cleveland State University.)

NEIGHBORHOOD BAR. As stores sprang up in the neighborhood, so did bars and taverns. By 1890, there were 23 Polish saloons operating in Cleveland. Ten years later, that number had more than doubled. The picture above was taken in the late 1890s. Notice the picture of the *Maine* on the wall behind the bar and the canary cage hanging from the ceiling. The bar was lit by gaslights and the canaries served to give an early warning of gas leaks, just as they did in the mines. Below are bar owners, John and Anna Szczerbacki. Few of the neighborhood saloons, survived the 18th Amendment to the U.S. Constitution, Prohibition, passed in 1920. By the time the amendment was repealed in 1933, most of the area's bars had closed. (Above, Irene Masters; below, Slavic Village Historical Society.)

BROADWAY SAVINGS AND TRUST BANK. The Broadway Savings and Trust Bank, founded in 1893, was one of the first suburban banks in the United States and the first in Cleveland. The bank was organized by Oliver Meade Stafford (see page 96) and Caesar A. Grasselli, president of the Grasselli Chemical Company. While the bank was being built, Stafford established his home on Drake (now Mumford) Avenue. (Slavic Village Historical Society.)

INTERIOR OF BROADWAY SAVINGS AND TRUST BANK. The Broadway Savings and Trust Bank merged with several other banks to become the Union Trust Company. Broadway Savings Bank failed during the Depression, but reemerged as the Union Bank of Commerce (Union Commerce Bank), which was absorbed by Huntington Bancshares. Today Hubcap Heaven occupies the former bank site at East Fifty-fifth Street and Broadway Avenue. (Slavic Village Historical Society.)

FIVE WORKERS AT THE CLEVELAND SOCIETY FOR THE BLIND. Caesar Grasselli, a noted philanthropist and son of the founder of Grasselli Chemical Company, was the president of Broadway Savings and Trust Bank in 1920 when the bank merged with several other institutions to form the Union Trust Company. He donated the family's Euclid Avenue mansion to form the Cleveland Society for the Blind (now the Cleveland Sight Center). The center provides job training, counseling, and other services to Cleveland's blind citizens. The organization stayed at that site until 1966. (Cleveland Press Collection/Cleveland State University.)

HOSMER TROLLEY ON EAST SIXTY-FIFTH STREET. East Sixty-fifth Street was the center of the original Warszawa (Little Warsaw) area of the neighborhood. In addition to businesses, the street ran along St. Stanislaus Church and school and the Orlikowski House, the large home of Polish businessman and city councilman Frank Orlikowski. (Slavic Village Historical Museum.)

CLASSROOM AT MILES PARK SCHOOL, 1901. The Miles Park area of Newburgh Township was first settled by James Kingsbury and Charles Miles (for whom the area is named) in the mid-19th century. Kingsbury built a house and mill along a stream at the present-day East Ninety-third Street and Union Street intersection that became known as Kingsbury Run. The Miles Park Historic District, located just north of East Ninety-third Street and Miles Road, includes four institutional buildings and 10 historic homes that date from the late 19th and early 20th century, including Miles Park School. (Slavic Village Historical Society.)

HARVARD GROVE CEMETERY. Harvard Grove Cemetery was something of an "instant" cemetery. The 20-acre property along Harvard Avenue was purchased by the City of Cleveland in 1880 as a place to reinter the approximately 3,000 residents of Newburgh Town Cemetery at Broadway Avenue and Aetna Road. The area surrounding Newburgh's original cemetery had become too populated, and during the winter of 1880, the residents of Newburgh Town Cemetery, which included several Revolutionary War dead, were moved to Harvard Grove Cemetery. (Cleveland Press Collection/Cleveland State University.)

HARVARD GROVE CEMETERY. In addition to the five Revolutionary War veterans, those buried at Harvard Grove include Alonzo Carter, the son of Lorenzo Carter, Cleveland's first permanent resident, and Isaac Reid, a neighborhood businessman whose land the city purchased to build the cemetery. (Slavic Village Historical Society.)

Two

Growth and Diversification

The Slavic Village neighborhood grew rapidly. Frugal mill workers saved a large portion of their wages and soon had families and property. Many, too, started small businesses—retail shops, butcher shops, and even banks—adding to the area's prosperity. Newburgh Township was gradually incorporated into Cleveland, with a small section remaining as the Village of Newburgh Heights.

The 1970s brought a renewed interest in the neighborhood's eastern European heritage and the Slavic Village nickname was born. In addition, the neighborhood began hosting the annual Slavic Village Harvest Festival, a combination of traditional food, music, and dance with the bounty of the region. Area development organizations also revamped the storefronts along Fleet Avenue, giving them a distinct Bohemian appearance that remains to this day.

Still, the advent of the highways and postwar prosperity made it possible for residents to move out of the neighborhood into Cleveland's eastern and southern suburbs. Many relocated to Parma, Maple Heights, Garfield Heights, and Independence.

ANNEXATION OF NEWBURGH TOWNSHIP. Most of Newburgh Township gradually became part of Cleveland, in 1874, 1878, 1893, and 1894. The remaining portion, located just south of the Cuyahoga Valley, was incorporated as the Village of Newburgh Heights in 1904. In 1917, a group of Newburgh residents seceded and formed Cuyahoga Heights. (Slavic Village Historical Society.)

FLEET AVENUE, 1947. Slavic Village continued to grow outward from the epicenter of St. Stanislaus Church until the neighborhood population was more than 75,000 at its height in the mid-1930s. (Cleveland Press Collection/Cleveland State University.)

OLD BESSEMER CREW, CLEVELAND STEEL WORKS, 1933. The first iron mill, the Cleveland Rolling Mill, opened in Cleveland in 1836. The construction of the canal at Sault Ste. Marie in Michigan's Upper Peninsula that year made it possible to easily get raw iron ore to Cleveland via Lake Erie. The company later became a part of U.S. Steel. (Cleveland Press Collection/Cleveland State University.)

BROADWAY AND MILES, 1933. Broadway Avenue and Miles Road in the 1930s was a center of commerce and activity. The area pictured above is barely recognizable as today's cluster of intersecting roads and railways. (Cleveland Press Collection/Cleveland State University.)

BROADWAY AND JEFFERSON AVENUE, 1932. The western edge of the Slavic Village neighborhood, near present-day I-490, is a good vantage point from which to view the 24-hour activity at the mills in the Cuyahoga Valley—then and now. (Cleveland Press Collection/Cleveland State University.)

STREET GAME, 1933. The residents of Slavic Village survived the Depression of the 1930s, as did most of Cleveland's ethnic communities, by emphasizing family and church and finding fun in unexpected—and free—places, such as the children in this neighborhood street game. (Cleveland Press Collection/Cleveland State University.)

NEWBURG POST OFFICE, 1936. The Newburg Post Office, located on Broadway Avenue near Holy Name Church, still serves the Slavic Village community. Constructed in the 1930s, the brick structure features classic art deco lines and detailing. Note that the *h* in Newburgh is added and dropped at will on buildings and in documents. (Cleveland Press Collection/Cleveland State University.)

CORT'S SHOES, 1935. As recently as the 1930s, Slavic Village residents had no need to venture downtown to buy the things they needed. Everything was available from stores right in the neighborhood, such as this shoe store on East Seventy-first Street. (Cleveland Press Collection/Cleveland State University.)

J. L. GOODMAN FURNITURE, 1938. Jacob L. Goodman Furniture Company, on Broadway Avenue, was founded in 1897. The company remained a family enterprise until it closed in 1993, and at one time had branches in Parma, Maple Heights, Rocky River, and Mentor. For several years after that, the site was home to Goodwill Industries. (Cleveland Press Collection/Cleveland State University.)

EJBL DRUGSTORE. Ejbl Drug was at one time, Cleveland's oldest drugstore. The popular store, founded in 1884, had two locations—at 7008 Broadway Avenue and 7812 Broadway Avenue. The former location was destroyed by fire on January 11, 1980, and its site is now designated as Solidarity Square, in honor of Poland's workers' movement. (Slavic Village Historical Society.)

CONSTRUCTION OF THE WILLOW FREEWAY, 1949. Willow Freeway, the forerunner to I-77, in 1949 divided what is now Newburgh Heights from the rest of the old neighborhood. From the air, it is easy to see the proximity of the mills to Slavic Village and why people who worked in those factories settled where they did. (Above, Robert Runyan/Bruce Young Collection; below, Ron Altman.)

FLEET AVENUE, 2008. In some ways, little has changed on Fleet Avenue since the early 20th century. Storefronts still line the wide avenue and residents shop at markets such as Seven Roses and Europa Deli. (Author's collection.)

Stepka's Hat Shop, 1950. Stepka's Hat Shop was just one of the many successful retail businesses along Broadway Avenue in the 1950s. This creative entrepreneur, city councilman I. P. Metzenbaum, combines hats with tax services. (Cleveland Press Collection/Cleveland State University.)

Washington Park Boulevard, 1953. Washington Park Boulevard cuts through the heart of Newburgh Heights and runs adjacent to the Washington Reservation of the Cleveland Metroparks. Newburgh Heights, located just west and south of Slavic Village, is the remaining portion of the former Newburgh Township and home to around 2,500 residents, down from a high of around 4,000 in the 1950s. (Cleveland Press Collection/Cleveland State University.)

JEAN'S TAVERN, 1951, AND GLINKA'S TAVERN, 1958. Taverns and neighborhood bars returned to Slavic Village after the end of Prohibition. Many, such as Jean's Tavern on East Sixty-fifth Street (above) and Glinka's, on Forty-second Street in Newburgh Heights (below), acted as social centers as well as drinking establishments. (Cleveland Press Collection/Cleveland State University.)

NORTH AMERICAN MANUFACTURING COMPANY, 1958. North American Manufacturing, on East Seventy-first Street, was just one of many thriving manufacturing facilities in and around Slavic Village in the 1950s. This Cleveland-based company makes winding machines, blowers, measuring equipment, and other industrial equipment. (Cleveland Press Collection/Cleveland State University.)

BROADWAY AT DILLE AVENUE, 1968. Soot and air population from the mills and factories along the Cuyahoga Valley have been neighborhood problems since the late 19th century. In this picture, taken at the eastern edge of the industrial area, the cloud that hangs over Slavic Village can be seen. (Cleveland Press Collection/Cleveland State University.)

DIVOKY HARDWARE. Divoky Hardware was one of many Polish-owned small businesses along Fleet Avenue in the early part of the 20th century. After the hardware store closed, the building was the home of Jaworski's Market for many years. Today the building houses a church and a pizza shop. (Ron Altman.)

NO. 3537 FLEET AVENUE, 1920S. Residents could find most anything they needed along Fleet Avenue in the 1920s. This enterprising shop owner added a single gas pump in front of his store to serve the growing number of automobiles in the neighborhood. (Ron Altman.)

SOLLY BAKERY. Solly Bakery was another of the family-owned businesses along Fleet Avenue. The Sollys remained in Cleveland for generations. In the 1980s and 1990s, Dale Solly won five Emmys in Cleveland for his broadcast journalism with WJW and WKYC News before moving to Washington, D.C. (Solly family.)

PORTAGE AND BROADWAY AVENUES, 1947. Portage and Broadway Avenues, near the present-day post office, was a bustling shopping area in the 1940s. Today the area near East Fifty-fifth Street is struggling to reinvent itself with projects like the renovation of the historic Atlas Building at East Fifty-sixth Street and Broadway Avenue. (Cleveland Press Collection/Cleveland State University.)

COMMITTEE TO BRING BACK BROADWAY, 1977. The 1970s saw a community effort to revitalize the old neighborhood. Spearheading this effort was the newly formed Committee to Bring Back Broadway, whose members included Kathy Munici (left), Rita Gaebelein (center), and JoAnn Roberts (right). (Cleveland Press Collection/Cleveland State University.)

FLEET AVENUE IN SLAVIC VILLAGE. The name Slavic Village was coined in 1977 by the Neighborhood Ventures Corporation, a group whose goal was to create a marketable identity for the old Polish and Czech neighborhood. One of their projects was to embellish the Fleet Avenue storefronts with an Old World theme. This group later became the core of the present-day Slavic Village/Broadway Development Corporation. (Cleveland Press Collection/Cleveland State University.)

POLES MARCHING ON FLEET AVENUE, 1982. Cleveland's Polish community continued to support its native land, even into the third and fourth generations. Pictured above are Slavic Village residents marching down Fleet Avenue in support of Poland's solidarity movement. (Cleveland Press Collection/Cleveland State University.)

FIRE AT THE CLEVELAND WORSTED WOOLEN MILL. By the mid-1990s, the once-thriving Woolen Mill had become a run-down shell of its former self and a neighborhood eyesore. The facility, closed as a mill in 1956, was being used as a warehouse for smaller companies. The huge brick complex was destroyed on July 4, 1993, when an explosion rocked the neighborhood and the subsequent fire brought down the structures that were once thought to be indestructible. Arson was suspected but never proven. (Glenn Sobola.)

FIRE DESTROYS WOOLEN MILL. Today all that remains of the Cleveland Worsted Woolen Mill is the old brick smokestack. The land on which the factory sat is now part of the Cuyahoga Valley biking and hiking trail and the Boys and Girls Club Complex. (Glenn Sobola.)

MILES PARK LIBRARY, 1930. The Miles Park Library, located at East Ninety-third Street and Miles Park Avenue on the site of the original Newburgh town square, is now the home of the Harriett Tubman Museum and Cultural Association, founded in 1990. (Cleveland Press Collection/Cleveland State University.)

MILES PARK SCHOOL, 1984. Miles Park elementary school, at the eastern edge of the Miles Park neighborhood, is just one of many historic buildings in the area that used to be a popular commercial district of Newburgh Township. (Slavic Village Historical Society.)

GARFIELD HEIGHTS. The advent of I-77, and later I-480, made it easy for neighborhood residents to move out to Cleveland suburbs. Many from the old neighborhood ventured out to Garfield Heights (above), Brecksville, Maple Heights, Parma, and Independence. (Cleveland Press Collection/Cleveland State University.)

Three

Churches, Clubs, and Schools

As with most ethnic communities, the area churches were the backbone of the Slavic Village neighborhood. Not only were they places to worship, but new arrivals relied on the church for housing and financial advice, language classes, job recommendations, and other services necessary to getting settled in their new home. Most of the Czech and Polish immigrants were Catholic, and no fewer than six Catholic parishes still remain in the neighborhood, including Cleveland's Polish Shrine Church, the Gothic St. Stanislaus.

Educating young residents was also a responsibility of the churches and most parishes have an affiliated elementary school. In the 1920s, more than 50 percent of the neighborhood's children attended parochial schools. Many of these institutions still thrive today, including St. Stanislaus's Cleveland Central Catholic High School.

In addition to the churches and schools, St. Alexis Hospital, created for the purpose of tending to sick and injured mill workers, grew into a neighborhood institution. Many, if not most, residents over a certain age began life at St. Alexis.

ST. STANISLAUS CHURCH, 1890s. St. Stanislaus Church is the traditional center of Slavic Village—both geographically and culturally. The church, founded in 1881, gave new Polish immigrants an opportunity to worship in their native language. The church also served as a social center, offering child care, a school, and letter-writing and translation services. (Slavic Village Historical Society.)

TORNADO DAMAGE, 1909. Disaster struck the growing Slavic Village neighborhood on April 21, 1909. For five minutes, a tornado spun its way across the neighborhood, leaving six people dead and more than $1 million in damaged property. Some of the worst damage was to St. Stanislaus Church, whose twin spires came crashing down during the storm. The church rebuilt, but the city did not allow the spires to be built to their original height. (Cleveland Press Collection/Cleveland State University.)

ST. STANISLAUS CHURCH. The church, located at Tod Street (now East Sixty-fifth Street and Forman Avenue), became the center of Cleveland's Warszawa neighborhood, an area that is now a Cleveland historic area. The church was entered into the National Register of Historic Places in 1976 and the church completed a $1.5 million renovation in 1998. (Cleveland Press Collection/Cleveland State University.)

ST. ROCH STATUE. The statue of St. Roch (St. Rocco), which stands in front of St. Stanislaus Church, was erected in 1919 in thanksgiving for the parish not losing any members in the influenza epidemic of 1918 and 1919. St. Roch, a Frenchman who eschewed his wealthy family to live simply and care of the sick, is the patron saint of epidemics, plagues, dog lovers, and hunters. (Author's collection.)

BAXTER AVENUE CEMETERY. Before St. Stanislaus Church was built and before the area became a predominantly Polish-Catholic neighborhood, the area was home to an enclave of eastern European Jews. Their cemetery, the old Bohemian Jewish Cemetery (renamed the Baxter Avenue Cemetery), is located adjacent to Central Catholic High School on Osmond Avenue and East Sixty-fifth Street. Most of the burials there were before 1903. (Terry M. Goodman.)

ST. STANISLAUS SCHOOL. St. Stanislaus School was created shortly after the church was founded and was administered by Franciscan nuns. Later the running of the school was given over to the nuns from the Holy Family of Nazarene. A high school was added in 1944. (Cleveland Press Collection/Cleveland State University.)

AT ST. STANISLAUS SCHOOL, 1964. A Catholic education was and is important to Slavic Village residents. Originally, the school at St. Stanislaus included grades one through six and taught classes in Polish. Today classes are in English and the school draws students from a number of ethnic backgrounds. (Cleveland Press Collection/Cleveland State University.)

ST. STANISLAUS SCHOOL, 1969. St. Stanislaus High School merged with three other Cleveland area Catholic high schools in 1969 to form Cleveland Central Catholic High School. Today the school has an enrollment of around 450 students. (Cleveland Press Collection/Cleveland State University.)

INSIDE ST. STANISLAUS CHURCH. Today St. Stanislaus Church continues to celebrate its Polish heritage with services in Polish, the traditional blessing of Easter baskets on the Saturday before Easter, and the church's annual Polish Festival, held the first weekend in October. (Terry M. Goodman.)

CELEBRATING A POLISH POPE. St. Stanislaus schoolchildren—and nearly everyone in the neighborhood—flocked to the church to celebrate the election of the first Polish pope, Pope John Paul II, in 1978. (Cleveland Press Collection/Cleveland State University.)

ST. WENCESLAS CHURCH. St. Wenceslas Church, founded in 1867, was Cleveland's first Czech Catholic parish. The church was located along Kingsbury Run at Arch Street (now East Thirty-fifth Street), near Woodland Avenue, and the parish relocated in 1899 to East Thirty-seventh Street and Broadway Avenue, where it served Czech residents until 1963, when it was demolished during the construction of I-77. (Slavic Village Historical Society.)

Our Lady of Lourdes. Our Lady of Lourdes Catholic Church, located on East Fifty-third Street just off of Broadway Avenue, was founded in 1883 to serve the area's growing Czech population. When it was built, it was the largest Bohemian parish in Cleveland. Today services are held in Spanish and English instead of in Czech. (Slavic Village Historical Society.)

PARADE IN FRONT OF OUR LADY OF LOURDES, 1966. The interior of Our Lady of Lourdes Church is noted for its many carved angels and the white intricately carved high altar. (Cleveland Press Collection/Cleveland State University.)

OUR LADY OF LOURDES SCHOOL, 1966. Our Lady of Lourdes continues to operate a school for children in kindergarten through eighth grade. (Cleveland Press Collection/Cleveland State University.)

IMMACULATE HEART OF MARY CHURCH. This Catholic church on Lansing Avenue was established by former St. Stanislaus pastor Fr. Anton Kolaszewski in 1894, after he quarreled with many parishioners and with the diocese over how St. Stanislaus should be managed. The Immaculate Heart of Mary parish thrives to this day, one of six Catholic parishes in the Slavic Village neighborhood. The current Romanesque structure was built in 1914. (Cleveland Press Collection/Cleveland State University.)

DENNIS KUCINICH AT IMMACULATE HEART OF MARY, 1979. The Immaculate Heart of Mary School opened in 1894. Originally the school was staffed with lay teachers, but the Sisters of St. Joseph of the Third Order of St. Francis took charge in 1911. Enrollment at the school peaked in 1932 at 1,350 students. (Cleveland Press Collection/Cleveland State University.)

ORDINATION OF CARDINAL KROL, 1937. John Cardinal Krol, a Polish American Clevelander, was ordained as a priest in 1937 at Immaculate Heart of Mary Church. Krol later served as archbishop of Philadelphia from 1961 to 1988. He was also a close advisor to Pope John Paul II after the later became pope in 1978. (Richard Kaliszewski/Union of Poles.)

St. John Nepomucene Church. St. John Nepomucene, at East Forty-ninth Street and Fleet Avenue, is another original Czech parish. The neoclassical church was founded in 1902, the second Czech parish in the neighborhood. It is named for one of the Czech Republic's patron saints. (Slavic Village Historical Society.)

INTERIOR OF ST. JOHN NEPOMUCENE CHURCH, 1953. St. John's, like most of the Slavic Village Catholic parishes, has an affiliated school, founded in 1903. The 2008 enrollment was 171 students in kindergarten through eighth grade. (Cleveland Press Collection/Cleveland State University.)

BROADWAY UNITED METHODIST CHURCH. Broadway United Methodist Church was founded in 1872 to serve the growing needs of the neighborhood's Protestant Czech community. The current structure at East Fifty-second Street and Broadway Avenue was dedicated in 1919. The stained-glass windows of the new church took a rather circuitous route getting to America. The advent of World War I prevented their shipment and the pieces, feared lost, were found in a German warehouse after the war and forwarded to Cleveland. (Above, Broadway United Methodist Church; right, Cleveland Press Collection/Cleveland State University.)

SACRED HEART OF JESUS CHURCH. The Sacred Heart of Jesus parish was another church founded by Fr. Anton Kolaszewski, the first pastor of St. Stanislaus Church. He started this parish in 1888 for the growing population in the Krakowa neighborhood (just west of East Seventy-first Street near present-day Cuyahoga Heights), many of whom were unable to walk the several miles to St. Stanislaus. (Cleveland Press Collection/Cleveland State University.)

ST. HYACINTH CHURCH. St. Hyacinth Church, founded in 1907, served the Polish immigrants who settled north of Broadway Avenue. The Hyacinth neighborhood now also includes the unique Hyacinth loft apartments, designed to accommodate filmmakers and other artists, and the restored Hyacinth Park. (Slavic Village Historical Society.)

HOLY NAME CHURCH. Holy Name Church, originally called the Church of Newburgh, was founded in 1854. It was the first Catholic church in Newburgh Township and originally served a mostly Irish congregation. Located on Broadway Avenue near Harvard Avenue, Holy Name is still an active parish and serves the community with an active hunger center and other outreach programs. (Author's collection.)

BARKWILL SCHOOL. Barkwill School, which sat on the site of the current Barkwill Park, just southwest of Broadway Avenue and East Fifty-fifth Street, was one of the oldest schools in Cleveland until it was torn down in the 1970s. The Polish residents of Slavic Village also sent their children to school at St. Stanislaus and the Czech children attended Tod School, located on Tod Street (now East Seventy-first Street), just south of Fleet Avenue. (Slavic Village Historical Society.)

OLD NORTH SCHOOL, NEWBURGH, 1938. The Old North School was one of the first schoolhouses in Newburgh Township. The frame structure, unused for decades, was finally demolished in the 1940s. (Cleveland Press Collection/Cleveland State University.)

SOUTH HIGH SCHOOL, 1912. Cleveland's South High School, located in Slavic Village, was the second high school built in the city of Cleveland. The original school (above), located one block west of the current building, was opened in 1894. (Slavic Village Historical Society.)

CLASS AT SOUTH HIGH SCHOOL, 1915. South High School thrived despite the fact that close to 40 percent of the neighborhood's children attended the many parochial schools in the area. (Cleveland Press Collection/Cleveland State University.)

SOUTH HIGH RECREATIONAL DANCE, 1948. Many present-day neighborhood residents graduated from South High School and have fond memories of their time there. (Cleveland Press Collection/Cleveland State University.)

SOUTH HIGH SCHOOL, 1980s. The current South High School, located at Broadway Avenue and Osage Street, opened in 1976. The former school became A. B. Hart Middle School. (Cleveland Press Collection/Cleveland State University.)

BROADWAY SCHOOL OF MUSIC AND THE ARTS. Cleveland's Broadway School of the Arts, located on Broadway Avenue at East Fifty-fourth Street, is listed on the National Register of Historical Places. The school offers specialized instruction to a carefully selected group of 200 students. Classes in music, dance, theater, and fine art are combined with the more traditional curriculum and students get an opportunity to perform via regular community concerts, plays, and recitals. (Slavic Village Historical Society.)

89

ST. ALEXIS, ORIGINAL BUILDING. St. Alexis began in 1884 in a private, eight-room, brick home on Broadway Avenue, where two nuns—Sisters M. Leonarda and M. Alexia of the Order of St. Francis of Perpetual Adoration—served the growing medical needs of those who worked in the factories of the Cuyahoga Valley. (Slavic Village Historical Society.)

THE SISTERS OF ST. ALEXIS. Sister M. Leonarda and Sister M. Alexia raised $5,500 in 1885 to expand the facility, and a 32-bed wing was constructed later that year. It was the second Catholic hospital in Cleveland. (Cleveland Press Collection/Cleveland State University.)

ST. ALEXIS HOSPITAL, 1951. St. Alexis further expanded in 1925, in 1930 when the School of Nursing was added, and in 1945 when it added a maternity wing. The 10-story main building was added in 1955. (Cleveland Press Collection/Cleveland State University.)

ST. ALEXIS STAFF. St. Alexis attracted a well-trained and dedicated staff. Several prominent Cleveland doctors were at one time part of the St. Alexis staff, including Frank Bunts, George Crile, and William Lower, three of the founders of Cleveland Clinic. (Cleveland Press Collection/ Cleveland State University.)

St. Alexis Hospital,
5163 Broadway Avenue, S. E. Cleveland, Ohio.

ST. ALEXIS HOSPITAL. In the 1920s, St. Alexis was the first hospital in the country to offer chemotherapy in its outpatient facility. In the hospital's prime, the facility offered a full range of services, including respiratory care, skilled nursing, senior services, women's services, rehabilitation services, and occupational health. (Cleveland Press Collection/Cleveland State University.)

CHAPEL AT ST. ALEXIS, 1955. St. Alexis retained a strong Catholic influence through the years, as witnessed in the lovely leaded glass window in the hospital's chapel depicting the story of the good Samaritan. (Cleveland Press Collection/Cleveland State University.)

St. Michael's Hospital. St. Alexis changed its name to St. Michael's Hospital in the 1990s. Although it became a part of Cleveland's University Hospital System in 2000, St. Michael's could not compete with the modern suburban medical centers. The venerable hospital closed in 2003, and the structure was demolished in 2007. (Cleveland Press Collection/Cleveland State University.)

Four

The People of Slavic Village

Although the architecture and the institutions of Slavic Village are interesting, it is the people who created the neighborhood and made it the ethnic stronghold of the early 20th century. Men like Oliver Stafford and Michael Kniola formed the institutions and businesses that helped to solidify the neighborhood.

Slavic Village spawned a variety of interesting persons. Strongman Stanley Radwan and Olympian Stella Walsh grew up in the neighborhood. So did United States congressman Dennis Kucinich, the youngest mayor of a major U.S. city when he was elected Cleveland's mayor in 1977.

Charles Barkwill House. Charles Barkwill was an early prominent businessman in Newburgh Township. During the 1850s, he ran a successful insurance agency at Broadway Avenue and East Fifty-fifth Street and contributed to many area charities. (Slavic Village Historical Society.)

OLIVER MEADE STAFFORD. Oliver Stafford was one of the organizers, in 1883, of the Broadway Savings Bank and Trust Bank at Fifty-fifth Street and Broadway Avenue. He also formed an insurance business with Michael Kniola (profiled on page 98), helped found Pulaski Park with Fr. Anton Kolaszewski, and served as president of Cleveland Power and Light. His name survives in Cleveland financial circles in the still-operating Brooks and Stafford Insurance Company. (Slavic Village Historical Society.)

LEON FRANZ CZOLGOSZ AND WILLIAM MCKINLEY. Not every notable Slavic Village resident is known for his good deeds. Leon Franz Czolgosz (right) entered the history books after shooting Pres. William McKinley (below) at the Pan American Exposition in Buffalo, New York, on September 5, 1901, inflicting a wound that would eventually kill the president. Before his execution later that year for his crime, Czolgosz said that he traveled to Buffalo so that he would not bring shame upon the old neighborhood. (Slavic Village Historical Society.)

MICHAEL KNIOLA. Michael Kniola was a prominent late-19th- and early-20th-century businessman in the neighborhood and friend to new Polish immigrants. He arranged loans, found housing for new arrivals, sold insurance and real estate, and founded Cleveland's first Polish newspaper, *Polonia w Ameryce* (Poland in America). He also started Kniola Travel Bureau in 1900, a business that still thrives in the neighborhood. (Slavic Village Historical Society.)

POLISH DAILY NEWS. Kniola's *Polonia w Ameryce* was just one of many ethnic newspapers published and distributed in the neighborhood. Among others were the *Polish Daily News* (right) and the Czech paper *Americke Delnicke Listy* (American Labor News). (Cleveland Press Collection/Cleveland State University.)

ORLIKOWSKI HOUSE. Frank Orlikowski was a brickmaker who supplied much of the material used to pave the streets in Slavic Village. His elegant brick home, constructed in 1893, still stands on East Sixty-fifth Street and Chambers Avenue. Frank's nephew Bernard was a key political figure in the neighborhood during the early to mid-20th century. He headed the Polish-American Realty and Trust Company and represented Cleveland's Ward 14 in city council from 1920 to 1927. (Terry M. Goodman.)

STELLA WALSH. Born Stanistawa Walasiewicz, Stella Walsh (1911–1980) competed for Poland in the 1932 and 1936 Olympic Games, earning a gold and silver medal respectively in the women's 100-meter track event. She set more than 100 Polish national and world track and field records and was inducted into the U.S. Track and Field Hall of Fame in 1975. Walsh, a resident of Slavic Village, was shot as a bystander during an armed robbery near her neighborhood home in 1980. She is buried in Cleveland's Calvary Cemetery. A neighborhood recreation center on Broadway Avenue (above) is named for her. (Author's collection.)

DENNIS KUCINICH. Dennis Kucinich, born in 1946, is one of the most visible sons of Slavic Village. He lived for a time in Slavic Village as a child and has continued to be an avid supporter of the neighborhood. Kucinich became the youngest mayor of a major U.S. city when he was elected Cleveland's mayor in 1977. He has also served as the area's congressman since 1997 and has twice run for president of the United States. Kucinich was instrumental in saving (at least temporarily) St. Michael's Hospital and finding a buyer for the defunct LTV Steel Mills. At left, Dennis Kucinich is pictured with Ted Kennedy at St. Alexis Hospital in 1971. (Cleveland Press Collection/ Cleveland State University.)

Five

Rediscovering Cleveland's Slavic Heritage

Today's Slavic Village resident is as likely to be of African American, Appalachian, or Puerto Rican descent as he is to be Polish or Czech. Yet the neighborhood unites in celebrating the history of the area. Several social and self-help organizations still thrive, such as the Alliance of Poles in America, a national organization founded in Cleveland to provide insurance to residents and offer hardship assistance and scholarships as well as social activities.

The Polish and Czech Sokols (falcons) have joined forces and still emphasize ethnic pride combined with physical fitness. University Settlement, one of Cleveland's original ethnic settlement houses, still serves the community with a food kitchen, senior center, and day care services, among other programs.

Look around the Slavic Village neighborhood and one is sure to see the red and white Polish eagle or rose painted on the side of a building or the Polish flag suspended from a home.

OUTSIDE OF THE WIADOMOSCI CODZIENNE OFFICE, 1937. The *Wiadomosci Codzienne* was just one of several Polish-language weekly newspapers in Cleveland. Others included *Związkowiec*, headquartered on Broadway Avenue, and *Kuryer*, based on Lansing Avenue in Slavic Village. (Cleveland Press Collection/Cleveland State University.)

ALLIANCE OF POLES PARADE, 1935. The Alliance of Poles of America, a national organization, was formed in Cleveland in 1895. The original group of 68 members quickly grew and offered insurance, social functions, loans and scholarships, and hardship assistance to members. The organization is still headquartered in Slavic Village, at East Sixty-ninth Street and Broadway Avenue. (Cleveland Press Collection/Cleveland State University.)

UNIVERSITY SETTLEMENT. Neighborhood settlement houses were a haven in many ethnic neighborhoods. They offered a place to get advice on housing, language training, banking, and other social programs. They also served as a social hub. Slavic Village's University Settlement was founded in 1926 and continues to serve the neighborhood today, with 21 different programs, ranging from adult day care to the Broadway Hunger Center. At left is a photograph of a dance at University Settlement in the 1940s. (Cleveland Press Collection/Cleveland State University.)

106

UNION OF POLES IN AMERICA. The Union of Poles, located for 75 years at Lansing Avenue and East Sixty-fifth Street, began as a fraternal insurance organization for eastern European immigrants to provide death benefits for its members. Affiliated with Fr. Anton Kolaszewski's Immaculate Heart of Mary Church, the organization branched out to offer social and cultural programs. The Union of Poles moved its facility to the Cleveland suburb of Garfield Heights in 2001. (Cleveland Press Collection/Cleveland State University.)

SOKOL POLSKI, 1947, AND POLISH FALCONS OF AMERICA, 1969. Sokol Polski (Polish Falcons) is an organization that promoted Polish nationalism as well as provided a community center, sports center, and meeting facility for Polish residents. The Cleveland chapter was established in 1909 and settled in this building at East Seventy-first Street and Broadway Avenue, where it stayed for more than 90 years. Today the Czech and Polish Sokols have merged and share a facility at East Forty-ninth Street and Broadway Avenue. Pictured at left are the 1969 members Joseph Oster, chairman; Bertha Modrzynski, president; and Zosia Salomon. (Left, Cleveland Press Collection/Cleveland State University; below, Slavic Village Historical Society.)

LADIES AUXILIARY, POLISH FALCONS OF AMERICA, 1940. Since originally membership in the Polish Falcons was limited to men, the ladies auxiliary was founded shortly after the Cleveland nest was established. (Cleveland Press Collection/Cleveland State University.)

BOHEMIAN NATIONAL HALL, 1947. The Bohemian National Hall, located at East Forty-ninth Street and Broadway Avenue, is said to be the first hall in Cleveland to be owned by an ethnic group. Czech settlers opened the venue in 1897. Over the years, the hall has served as a meeting place, a Czech-language school, and a recreation center. In 1975, the hall combined with Sokol Cleveland, which led a restoration effort. The hall was added to the National Register of Historic Places in 1977. (Slavic Village Historical Society.)

HARMONICA CHOPIN SOCIETY, 1927. The Harmonica Chopin Society was formed by Poles in Slavic Village in 1902 as a way to preserve the music and culture of the old country. By the 1920s, the group featured more than 100 voices. They continued to perform until the 1990s. (Cleveland Press Collection/Cleveland State University.)

ANTON ZVERINA BUILDING. Subtle reminders of the neighborhood's eastern European heritage can still be found around the area. A Mail Pouch Chewing Tobacco advertisement—the only one remaining in the Czech language—can be found on the Anton Zverina Building at East Fifty-third Street and Broadway Avenue. Zverina's, established in 1884, was a grocery store and sold coffee from Wilson's Mill on Canal Road among other staples. (Glenn Sobola/ Slavic Village Historical Society.)

POLISH EAGLE. The red and white eagle—a symbol of Poland—is frequently used to decorate buildings and signs in Slavic Village, as on this Heisley Road building. (Terry M. Goodman.)

NATIONAL COSTUMES, 1963. Residents of Slavic Village often don the traditional costumes of Poland and the Czech Republic for festivals, such as the now-defunct All Nations Festival Slavic Village Harvest Festival. (Cleveland Press Collection/Cleveland State University.)

CELEBRATING POLISH CONSTITUTION DAY. Each year, residents of Slavic Village commemorate Poland's Constitution Day, May 3, with a parade and the displaying of the Polish Flag all along Fleet Avenue and East Sixty-fifth Street. May 3, 1791, was the date on which Poland became a nation. (Cleveland Press Collection/Cleveland State University.)

GRABINSKI'S MARKET ON FLEET AVENUE, 1977. The name Slavic Village arrived in the mid-1970s as the community strove to create a marketable identity for the neighborhood, similar to what was being done in Cleveland's Little Italy. They began transforming many of the deteriorated buildings along Fleet Avenue into a uniform Polish "Hylander" style. (Cleveland Press Collection/Cleveland State University.)

FLEET AVENUE, 1977. Fleet Avenue took on a decidedly Bohemian air after the storefront renovations of the mid-1970s. Much of the Hylander detailing, from East Fifty-fifth Street to East Sixty-fifth Street, still remains. (Cleveland Press Collection/Cleveland State University.)

SLAVIC VILLAGE HARVEST FESTIVAL, 1980. Each August from 1977 to 2008, Clevelanders joined the residents of Slavic Village to celebrate the end of summer at the Harvest Festival. Fleet Avenue was closed to traffic and two music stages were set up—one at either end of the street. Of course, there were polka bands, dancing, and generous servings of pierogi and potato pancakes. (Cleveland Press Collection/Cleveland State University.)

POLISH VETERANS, 1978. After the invasion of Poland in 1939, the action that prompted World War II, many Cleveland Poles went to Canada to enlist in the Polish forces fighting Germany. Others, like those above, enlisted in the U.S. armed services when this country entered the war in 1941. Cleveland's Polish community is justifiably proud of its military service. (Cleveland Press Collection/Cleveland State University.)

JAWORSKI'S MARKET, 1990S. Jaworski's was one of several sausage shops along Fleet Avenue. Today Jaworski's has moved to Middleburg Heights, one of Cleveland's southern suburbs. The only sausage shop that still remains within Slavic Village is Krusinski's. (Author's collection.)

KRUSINSKI'S MARKET, 2007. Krusinski's Finest Meats, originally on Fleet Avenue and now on Heisley Avenue, is just one of a half dozen traditional Polish sausage shops, bakeries, and food stores that thrive in the old neighborhood. Krusinski's sells handmade pierogi through the store and wholesale to restaurants all around northeast Ohio. (Cleveland Press Collection/Cleveland State University.)

SEVEN ROSES DELI, 2008. This traditional deli/sandwich shop on Fleet Avenue in the heart of Slavic Village is a delight to all the senses. The displays of baked goods and Polish groceries here are as mesmerizing as the house-made potato pancakes, soups, baked goods, and pierogi are delicious. (Terry M. Goodman.)

RED CHIMNEY RESTAURANT. The Red Chimney, located at Fleet Avenue and East Sixty-fifth Street, is more than a coffee shop. In business since 1980, it is the hub of neighborhood activity. Here one will find councilmen, police officers, Polish matrons, and local newscasters all enjoying the affordable breakfasts, homemade pies, and Polish specialties. (Terry M. Goodman.)

GERTRUDE BAKERY. Located on Gertrude Avenue, just off East Sixty-fifth Street, Gertrude Bakery is one of the few that remain of what was once a plethora of corner bakeries. Enter the shop to be transported back a half century with smells of freshly baked bread, pastry, and pies, all sold from classic glass-front counters. (Author's collection.)

Six
LOOKING FORWARD

Today Slavic Village sits at a crossroads between development and decay. New housing projects sit adjacent to boarded-up homes—a result of the huge number of home foreclosures in the neighborhood. Still, the proud, hearty residents of this interesting and diverse neighborhood stand firm against the elements that would drive them out of the area.

There are hopeful signs. A new elementary school is being built on Ackley Road. Central Catholic High School continues to expand, and the Fleet Avenue storefront renovation initiative has resulted in new businesses and refurbished store facades.

Elements of Slavic Village's Polish and Czech roots can still be found in the Polish language one hears spoken in the neighborhood stores, in the Polish baked goods found in the bakeries and markets, and at the festivals and parades that celebrate the neighborhood and its history.

KARLIN HALL. This Czech social club on Fleet Avenue and East Fifty-third Street has been a popular meeting place and polka dance hall since it opened in 1935. The location threatened to close in 2007, but popular demand (and an influx of donations) allowed the club to remain open. (Author's collection.)

BRILLA HOUSE, 2008. The Brilla House is home to the Slavic Village Historical Museum, located just off of Warner Road at the eastern edge of Slavic Village. The museum, opened in 2002, features a changing array of exhibits about the neighborhood's past and future. The building also houses an extensive archive of photographs, newspaper articles, and other items of historic significance to Slavic Village. (Author's collection.)

THE CLOISTERS. The Cloisters, on East Sixty-fifth Street near St. Stanislaus Church in the Warszawa area, is just one example of new construction in the Slavic Village neighborhood. The three-phase project, begun in 2005, features 22 townhomes designed around a center courtyard. (Terry M. Goodman.)

MILL CREEK DEVELOPMENT. Mill Creek is another successful Slavic Village housing project. The 200-home development is located near the Slavic Village Historical Museum, on Turney Road near Miles Park. The planned community features hiking trails, its own bus stop, two parks, and a community center and swimming pool. (Author's collection.)

THIRD FEDERAL SAVINGS AND LOAN. A fixture in Slavic Village since 1938, Third Federal Savings and Loan has grown from a modest storefront to its current 230,000-square-foot campus on Broadway Avenue. Although the company has expanded into other parts of Ohio and even Florida, they remain committed to neighborhood development and have funded many recent housing projects. (Terry M. Goodman.)

BEN STEFANSKI, 1976. Third Federal was founded by Ben Stefanski and his wife, Gerome. In fact, the couple spent their honeymoon in Washington in 1937 applying for the charter for the new savings and loan. Ben was a son of the neighborhood and attended South High School. He died in 1991 and is buried in Cleveland's Calvary Cemetery. Third Federal is now run by the couple's son Marc. (Cleveland Press Collection/Cleveland State University.)

NEW ADDITION TO ST. STANISLAUS SCHOOL. Cleveland Central Catholic High School continues to grow, as witnessed by the new addition to the school, completed in 2007. The school currently serves approximately 560 students. A new athletic complex is also under construction near Morgana Park. (Terry M. Goodman.)

MORGANA PARK. Many a Slavic Village resident has fond memories of playing Little League baseball at Morgana Park on East Sixty-fifth Street, just south of Broadway Avenue. Today the park is being refurbished and will share the site with the new Central Catholic High School sports complex. (Author's collection.)

123

WASHINGTON RESERVATION. At the western edge of Slavic Village, between Cleveland and Newburgh Heights, sits the Washington Reservation (formerly Washington Park), a part of the Cleveland Metroparks system. Facilities at the 59-acre park include the Cleveland Public Schools' Horticulture Education Center and the Washington Park Golf Course, a nine-hole course and learning center that opened in 2006. (Author's collection.)

BOYS AND GIRLS CLUBS OF CLEVELAND. The $7 million Boys and Girls Clubs of Cleveland complex opened in 2004 on the site of the ruined Cleveland Worsted Woolen Mills. The 27,000-square-foot facility sits on 12 acres and includes a gymnasium, classrooms, a baseball diamond, and a soccer field. The center offers young residents, ages 6 to 18, activities, skills, and tools to help them successfully face life circumstances. (Terry M. Goodman.)

A Typical Slavic Village Street. Today one is as likely to find residents of Appalachian, African American, and Puerto Rican descent in Slavic Village as those of Czech and Polish heritage. However, one can still bank at Third Federal and order lunch in the old language at Seven Roses Deli. (Terry M. Goodman.)

Challenges to the Old Neighborhood. Even as new housing developments and projects emerge, Slavic Village faces a variety of challenges, including absentee landlords, empty houses, truancy, and crime. How Cleveland deals with these issues in Slavic Village will likely determine the fate of the historic neighborhood. (Terry M. Goodman.)

FORECLOSURES AND ABANDONED HOUSES. National news teams filled the restaurants and delis on Fleet Avenue when it was announced in 2007 that zip code 44105, which includes the Slavic Village neighborhood, had more foreclosures than any other area of the country. That year, 1 in 11 houses in Slavic Village was boarded up. In 2009, the situation has stabilized somewhat, but it is a rare Slavic Village street that does not have at least one boarded-up house. (Terry M. Goodman.)

STAY OR GO? The *Cleveland Plain Dealer* wrote in 2007, "If Cleveland can't save Slavic Village, it can't save itself." At the end of the decade, the fate of the old neighborhood is still in flux. Derelict houses sit beside new construction and many second—and third—generation residents are staying in their homes, waiting for the upswing. Still, whether to move or stay is the unspoken question in virtually all neighborhood residents' minds. (Author's collection.)

HOPE FOR THE FUTURE. The people in Slavic Village, many of whom can trace their roots back to the influx of immigrants in the late 19th century, are far from giving up on the old neighborhood. Amid the abandoned homes are carefully manicured houses with window boxes full of vibrant flowers and well-kept lawns, and the neighborhood festivals and food stores remain popular. More than $200 million has been spent in Slavic Village in the last decade and future plans include a new Mound Elementary School at Ackley and Linton Roads and more than 200 additional new houses. (Terry M. Goodman.)

DISCOVER THOUSANDS OF LOCAL HISTORY BOOKS
FEATURING MILLIONS OF VINTAGE IMAGES

Arcadia Publishing, the leading local history publisher in the United States, is committed to making history accessible and meaningful through publishing books that celebrate and preserve the heritage of America's people and places.

Find more books like this at
www.arcadiapublishing.com

Search for your hometown history, your old stomping grounds, and even your favorite sports team.

Consistent with our mission to preserve history on a local level, this book was printed in South Carolina on American-made paper and manufactured entirely in the United States. Products carrying the accredited Forest Stewardship Council (FSC) label are printed on 100 percent FSC-certified paper.

MADE IN THE USA